Personal Vision

The Batkin Collection of Israeli Art

Yeshiva University Museum

The Jewish Museum, New York
July 2–October 6, 1985

Exhibition Curator: Susan Tumarkin Goodman
Editor: Michael Sonino
Graphic Design: William R. Tobias Design, Inc.
Typography: S. Smith, Inc.
Installation Design: Clifford La Fontaine
Printing: Universal Folding Box Co., Inc.

Special Thanks:
Stanley Batkin, Jacobo Furman, Jacob Schulman

Cover illustration: Lea Nikel, *Painting in Red,* 1966

Library of Congress Catalog in Publication Data
Main entry under title:

Personal vision, the Batkin collection of Israeli art.

An exhibition catalog.
1. Art, Israeli—Exhibitions. 2. Art, Modern—20th
century—Israel—Exhibitions. 3. Batkin, Stanley—Art
collections—Exhibitions. 4. Art—Private collections—
United States—Exhibitions. I. Goodman, Susan Tumarkin.
II. Jewish Museum (New York, N.Y.). III. Title: Batkin
Collection of Israeli art.
N7277.P47 1985 709′.5694′07401471 85-12597
ISBN 0-87334-031-0

Photographic Credits: Numbers refer to page in catalogue.

Stanley I. Batkin: 10, 11, 19 right, 20, 21 left, 25, 37,
Malcolm Varon: 9, 12–18, 19 left, 21 right, 22–24,
26–36, 38, 39.

Foreword

Exhibitions devoted to private collections offer considerable enrichment to museum visitors—who are themselves collectors of experiences. By seeing such collections, a viewer can not only obtain vicarious pleasure in sharing the process of collecting and owning works of art, but can also have the benefit of participating in a personal vision that is often enhanced by years of connoisseurship on the part of the collector. This personal vision is expressed through art works the collector has chosen through the stimulus of his or her ideals of aesthetic beauty, art-historical importance, or rarity; and also because such works embody specific meanings relative to the collector's individual tastes and values. Such exhibitions are also inestimably productive, as they often may inspire aspiring collectors to form their own collections, thus enhancing their own lives while at the same time invigorating those of scholars and art lovers.

The present exhibition comprises three outstanding private collections that are being shown simultaneously: the Batkin Collection of Israeli art, the Furman Collection of Jewish ceremonial art, and the Schulman Collection of twentieth-century American painting and sculpture. Although the kind of art represented by the works in each collection is quite different, each has been informed and inspired by the collector's Jewish identity. The works range from objects created specifically for Jewish ritual purposes to avant-garde works from modern Israel. Since the three collections represent Jewish art from a variety of perspectives, to a large degree they represent the ideal collecting and exhibition mandates of any museum concerned with Jewish culture.

The creation of these three exhibitions and the preparation of the accompanying catalogues has been achieved through the fruitful collaboration between the collectors and the museum's curators, with the assistance of staff and consultants. Our deepest appreciation and gratitude is extended to Selma and Stanley Batkin, Asea and Jacobo Furman, and Selma and Jacob Schulman for making their collections available to us. They are also to be thanked for providing the informative introductory essays that clarify the motivations and concerns behind the formation of their collections, as well as for their unstinting generosity in helping make this project possible.

Special thanks are due to the two curators responsible for the mounting of this triple exposition: Susan Braunstein, for her scholarly research and sensitive selection of Judaica from the Furman Collection, and Susan Tumarkin Goodman, for her keenly informed perspective in selecting works from the Batkin and Schulman collections. In addition, the entire museum staff has been most helpful in providing the administrative and operational support necessary for the realization of the exhibitions, and the necessary publicity that integrates these exhibitions within the Museum's overall public programming. The designers and editorial consultants have also contributed invaluable assistance in this ambitious project.

The Jewish Museum greatly appreciates this opportunity to offer these collections to public view, and by so doing further enhance the public's experience of the richness and variety inherent in Jewish art and culture.

Joan Rosenbaum, Director

Introduction

Stanley and Selma Batkin are two exceptionally dedicated collectors with a passion for documenting the story of Israeli art, thereby manifesting their commitment to Israel and its community of artists. The great range of works brought together by the Batkins offers a highly personal choice of Israeli art, and comprises a selective survey of thirty-five artists and major styles that have emerged during the last six decades of Israel's growth.

The works range in time from a 1917 pastel by Abel Pann to recent oil paintings by Ivan Schwebel and Joshua Neustein. The major criteria that inspired the selection include the importance of the particular artist within the context of the history of Israeli art, the representative nature, and the quality of the individual piece within the context of the artist's oeuvre.

Collecting provided the Batkins with the means of becoming actively involved with the development of the State of Israel. Numerous trips to Israel offered them the opportunity to provide direct artistic patronage, which benefited both artists and galleries. The pleasure of collecting also became associated with the joys derived from personal contact with the artists. This contact has often been faciltated by Stanley Batkin's work as a photographer, an avocation through which he has become acquainted with many artists and other prominent members of the Israeli cultural community. In fact, the acquisition of a work has often followed an initial contact made through photographing the artist. From 1968, when their first painting by Yaacov Agam was acquired, Stanley and Selma Batkin have slowly but steadily assembled their eclectic collection. Rather than concentrate on a specific artist or period, they have sought to be comprehensive, acquiring works which reflect a wide diversity of styles. This broad interest has resulted in the acquisition of a number of important pieces, among them *Untitled*, a 1969 oil on wood painting by Arie Aroch, *The Clown*,

a 1925 figurative canvas by Tziona Tagger, and a lyrical abstraction, *Zila*, 1965, by Yeheskel Streichman.

Naturally, the selected work of thirty-five artists cannot adequately represent all of Israeli art; however, this collection offers intense impressions of artistic developments within the nation. Each of the artists chosen for this exhibition has contributed to the profile of Israeli art, some—such as Yaacov Agam, Mordecai Ardon, Reuven Rubin, and Marcel Janco are internationally celebrated; the reputation of others is more local.

Diversity is represented not only in style but in the cultural origins of the artists, as is indicated in the biography of each. The fact that they are Jewish or Israeli is not readily discernable in their artistic expressions which transcend boundaries and explicit content to speak an international language. These artists neither follow nor espouse a particular style, nor do they embrace a single dogma, and their origins, training, and practice are quite dissimilar. Each, however, expresses in art the sum of his or her personal background and experience. In a sense, the diversity of the Batkin Collection epitomizes Israel itself.

The emergence of Israeli art has an accepted historical date—1906, the year in which the Bezalel School of Arts and Crafts was founded in Jerusalem by Boris Schatz. After an early emphasis on the applied arts, the outlook of the school was broadened by the arrival of immigrants conversant with varying aspects of the European modernist movements. Included in the present exhibition are a number of paintings by the early Palestine artists. Israel Paldi's *Impressions of Safed*, 1927; Zvi Shor's *Tel Aviv*, 1929 and Tziona Tagger's *Old City, Jerusalem*, 1936 represent this early generation of young idealistic artists who were struck by the exotic culture and the amazingly varied landscape. Their work documents a search for a straightforward pictorial vocabulary that would be appropriate to express the actuality of their new cultural identity and environment.

Another wave of artists emigrated from Germany in the 1920s and 1930s, and the drawings and paintings of Mordecai Ardon, Anna Ticho, Leopold Krakauer, and Jacob Steinhardt exalt and interpret the city of Jerusalem, where each settled after arriving in Palestine.

Many of the pioneering abstractionists joined together after the founding of the state of Israel in 1948 to form the New Horizons group. In the work of a number of these artists, European influences were synthesized in semi-abstract figure and landscape paintings. Examples of paintings in the Batkin Collection by Marcel Janco, Avigdor Stematsky, Yeheskel Streichman, and Yosef Zaritsky attest to determination to free Israeli painting from its local character and literary associations, in order to focus on a universal and contemporary idiom.

Works by succeeding generations of artists no longer reflect a uniform stylistic or ideological affinity. They run the gamut from paintings by Arie Aroch and Aviva Uri—which emphasize the artists' personal "handwriting" as a vehicle for subjective expression—to the pure abstractions of Yaacov Agam, Lea Nikel, and Yosef Zaritsky. Contemporary trends in Israeli art are represented in the sculpture of Dani Karavan and Menashe Kadishman, and in the painting of Joshua Neustein, Pinchas Cohen Gan, and Ivan Schwebel, each of whom exemplifies the current artistic directions prevalent in the various international art centers.

The scope of the Batkin Collection is particularly notable in the number of works from the 1920s and 1930s represented side by side with those made more recently by artists during the 1960s and 1970s. Over the years, Selma and Stanley Batkin's collecting has concentrated on works expressing a figurative idiom, a reflection of their taste that has recently become more defined and focused. The collection is singularly personal, and while it currently has outgrown the bounds of the Batkin's suburban home, the scale of most of the works has a domestic rather than an institutional orientation. The art is displayed in a random fashion, allowing the collectors to establish that intimacy and relationship which ownership so uniquely provides.

The selected works in the current exhibition only highlight some of the more important examples of painting and sculpture in the collection, and represent a mere portion of Stanley and Selma Batkin's holdings of Israeli art. Nevertheless, they vividly attest to the range and taste of these collectors.

I wish to thank Stanley and Selma Batkin for their long-standing interest in The Jewish Museum. Stanley Batkin's cooperation and participation in this exhibition is highly valued and appreciated. We are also grateful for his prefatory statement that elucidates the process by which, within a relatively short span of time, a collection of this scope was assembled.

In conclusion, I would like to thank the staff of The Jewish Museum, whose efforts contributed to the realization of *Personal Visions*: in particular Joan Rosenbaum, Director, for her care and attention in all phases of the exhibition; and to Harley Spiller, Exhibitions Assistant, and Caren Levine, Administrative Assistant, whose patience and assistance in connection with the exhibition and catalogue preparation were invaluable. I also wish to acknowledge Martha Siegel for her research on the artists' entries included in the catalogue of the exhibition.

Susan Tumarkin Goodman
Chief Curator

A Personal Statement

Stanley I. Batkin

When I visit a museum or gallery I often find myself wondering about the artists and collectors of the works on exhibit. What kind of people are they? What are the underlying factors that have inspired them to become collectors and what motivated the choice of a particular artist or style of painting or sculpture? And in the case of an artist, what has led him or her to adopt and develop a particular style or idiom? The average museum- or gallery-goer is often unfamiliar with the artist and his or her personality. They see the works as seemingly unrelated rather than as a cohesive, logical collection in which the whole is greater (and has deeper implications for the collector or the artist) than the sum of its individual parts.

I have long felt that in exhibitions it is the collector who establishes the parameters, who defines the selective process, and who, consciously or not, infuses upon the collection a good measure of personal taste and artistic judgment. I am therefore grateful to The Jewish Museum, to its Director, Joan Rosenbaum, and to its Chief Curator, Susan Goodman, for providing me with the opportunity to offer this brief introduction to the current exhibition chosen from our collection of Israeli art. It should be mentioned that the works shown here represent about one third of our entire collection, and that the selection was determined by the Chief Curator of The Jewish Museum.

Until some twenty years ago—that is, for the greater part of our adult lives—my wife Selma and I collected without focus works which we acquired through decorators and galleries. These pictures gave a pleasant effect to our home, but as they were impersonal choices we felt no attachment to them. We had never met any of the artists who painted them, and the pictures themselves—French chateaux or English hunting scenes—had no connection with our lives and did not reflect our personalities. Also, except for a few pieces of Judaica and the usual library of books on Jewish history and similar related subjects, there was nothing relevant to aspects of Jewish or Israeli culture.

Then, in 1960, I became Chairman of the building committee of Beth El Synagogue of New Rochelle, which was about to embark on the construction of a new house of worship. In this position, I undertook the responsibility of planning and overseeing the design and the many decorative elements for the proposed structures. This gave me the opportunity to spend years engaged in research and to accumulate information in anticipation of my task. The result was a decision to include fifteen artistic projects based on studies of the Bible, the Commentaries, synagogue literature, and so forth. I had decided to commission Israeli artists for these projects in recognition of the indivisible bond that exists between the Jews of the Diaspora and the Jews of Israel. To implement this decision, I began to make frequent visits to Israel in order to discuss my ideas with a number of artists. These encounters were most rewarding, as they opened new horizons to me and expanded my fields of interest. While arranging commissions from various art-

ists for the new building, I also began to acquire art works for our home. At about this time the Limited Editions Club published *The Dead Sea Scrolls* with illustrations by Shraga Weil, a member of Kibbutz Haogen; and while in Israel we visited the artist and purchased several of the watercolors that had been reproduced in this volume. One of these was *The Reader*, and in bringing this work into our home we realized that the decorative pictures mentioned earlier had no connection at all with our lives. Thus, we began to collect works by Israeli artists, as well as ancient Palestinian glass and pottery, and similar antiquities.

In my decision to collect works by Israeli artists I was guided by my usual principle: to strive for excellence, whatever the endeavor might be. At the start our collection grew slowly, but the pace accelerated as we broadened our knowledge. In the process, we met hundreds of artists and others associated with the art world, and soon made lasting friends with many of these individuals. We also became active participants in a number of museums in Israel and America, and I now serve on the boards of directors of several of these institutions. At first, the collection consisted mostly of graphic works—serigraphs, lithographs, and the like. After a few more years of immersing ourselves more deeply into the world of art, we decided to concentrate on assembling a collection of paintings and sculptures by established figures as well as those by outstanding younger, and as yet relatively unknown, artists.

At the time of writing, our collection includes works by more than ninety Israelis, from the earliest Palestinian artists of the Bezalel School such as E. M. Lilien and Ze'ev Raban, to young contemporary artists, an eighty-year span that encompasses representative examples in all styles from realist to abstract. Most of the collection reflects our personal taste, and many works were acquired before the artists attained the fame they now enjoy. We are ever in the process of upgrading our collection, continually acquiring important works by new artists, as well as those already represented in the collection. Decisions on what to acquire are based on several factors: our appreciation of the work, the advice of art experts and others, a desire to own at least one major work by every leading Israeli artist, and our wish to support new artists of promise. As a photographer, I try to utilize a discerning eye in recognizing salient aesthetic factors, and my professional expertise in the area of color printing aids in my comprehension of color values.

A week never goes by without my receiving a letter, a visit, or a phone call from people in the Israeli art world. The result of these varied activities has been the transformation of our home into a kind of domestic museum devoted to Israeli art. Our lives have been enriched through our friendship with many of the artists whose work is included in the collection, with museum people, and with many persons connected with the art world in general. This participation has been stimulating, and has been instrumental in opening a new world to us.

Catalogue of the Exhibition

8

Yaacov Agam
Mordecai Ardon
Arie Aroch
Aharon Avni
Yosl Bergner
George Chemeche
Pinchas Cohen Gan
Fima
Haim Glicksburg
Nahum Gutman
Marcel Janco
Menashe Kadishman
Dani Karavan
Joseph Kossonogi
Leopold Krakauer
Zvi Mairovich
Joshua Neustein
Elias Newman
Lea Nikel
Israel Paldi
Abel Pann
Reuven Rubin
Zvi Shor
Ivan Schwebel
Shalom of Safed
Jakob Steinhardt
Avigdor Stematsky
Yeheskel Streichman
Hermann Struck
Tziona Tagger
Moshe Tamir
Anna Ticho
Aviva Uri
Shraga Weil
Yosef Zaritsky

Height precedes width; where
applicable, depth follows width.

Yaacov Agam

Born (Gipstein) Rishon-le-Zion, Palestine, 1928
Lives in Paris and Rehovot, Israel

A pioneer and innovator in kinetic art, Yaacov Agam first studied under Mordecai Ardon at the Bezalel School of Arts and Crafts in Jerusalem in 1946. He moved to Europe in 1949, studied in Zurich for two years, and then settled in Paris in 1951. It was there that he began his experiments with optical effects, developing a style of art that incorporates kinetic elements in such a way that changes are effected in the piece as the spectator moves. Agam's abilities have found expression in painting, murals, sculpture, jewelry, and stage sets; and his work has evolved into intricate and complex structures, as well as those incorporating acoustic and lighting effects. In 1970 he received the Sandberg Prize and he was recognized with an honorary doctorate of philosophy from Tel Aviv University in 1975. Over one hundred exhibitions of his work have been held in the United States, Europe, and Israel, and in 1980 Agam was accorded a one-man show at The Guggenheim Museum in New York.

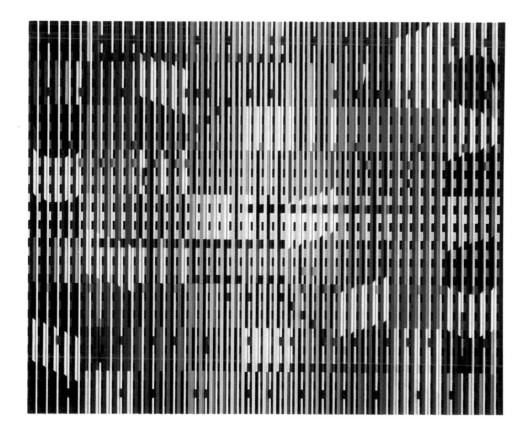

From Birth To Death, 1972
Oil on aluminum
32 x 37"

Commissioned: 1967
Acquired: 1972

Yaacov Agam

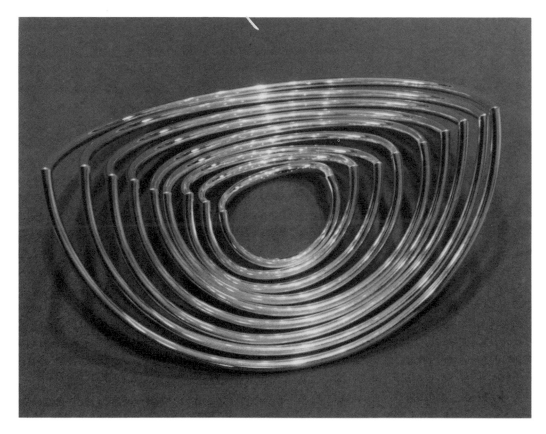

The Beating Heart, 1972
Gold-plated copper
4½ x 7½ x 4½″

Acquired: 1972
Provenance: the artist

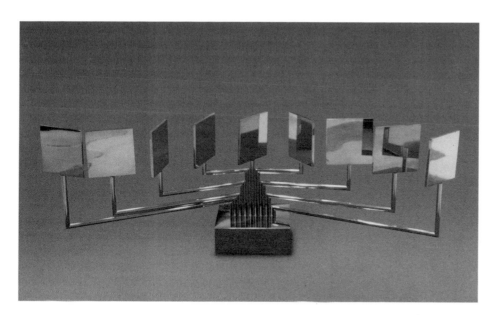

Light in Movement, 1977
Gold-plated brass
(Number 1 of an edition of 6)
9 x 28 x 5"

Acquired: 1977
Provenance: the artist

President's Candelabra, 1971
Gold-plated brass
4½ x 7 x 2"

Acquired: 1972
Provenance: the artist

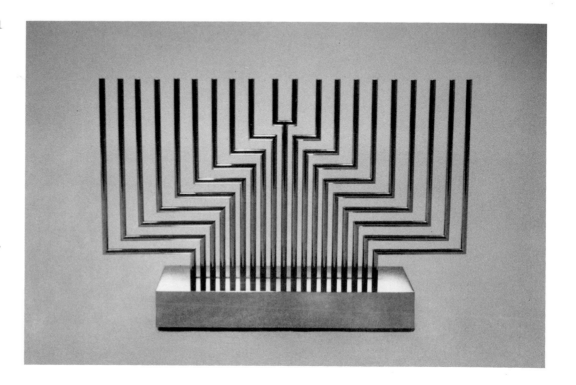

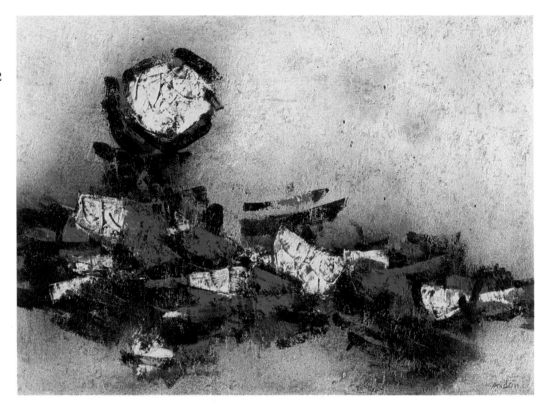

Jerusalem Landscape, 1977
Oil on canvas
21¼ x 28¾"

Commissioned and acquired: 1977

Mordecai Ardon

Born (Bronstein) Tuchow, Poland, 1896
Lives in Israel and Paris

Mordecai Ardon received his first formal training in art between 1921 and 1925 at the Bauhaus in Weimar, where he studied under Johannes Itten, Lyonel Feininger, Wassily Kandinsky, and Paul Klee. In his landscapes and his more abstract compositions, Ardon's art reflects a union of this early formal education with the more traditional Eastern European Jewish values, and he depicts symbolic and allegorical themes in pure and luminous colors. After immigrating to Palestine in 1933, Ardon taught at the Bezalel School of Arts and Crafts in 1935. He was director of that institution from 1940 to 1952, and while there he stressed the value of fundamental and systematic training in art, such as that which prevailed at the Bauhaus. From 1956 to 1962 he was appointed artistic advisor to the Ministry of Education. Ardon has also lectured at Hebrew University in Jerusalem. His awards and honors include the 1954 UNESCO Prize of the Venice Biennale, the 1963 Israel Prize, and an honorary doctor of philosophy degree from Hebrew University in 1974. In 1984 Ardon completed a large stained-glass window at the National and University Library in Jersualem and a retrospective exhibition of his work opened at the Tel Aviv Museum in May, 1985.

Arie Aroch

Born Kharkov, Ukraine, 1908
Died Jerusalem, 1974

Upon immigrating to Palestine in 1924, Arie Aroch began studying art at the Bezalel School of Arts and Crafts in Jerusalem. In 1924 he continued his studies at the Académie Colarossi in Paris, and for a while thereafter his work was influenced by that of his teacher, Fernand Léger. In 1948, however, as a cofounder of the New Horizons group, Aroch's style changed; but unlike the informal, lyrical abstractions espoused by his colleagues, Aroch sought to develop a type of abstract art incorporating specific, "concrete," and identifiable images. In 1948 Aroch entered the diplomatic service as Israeli Ambassador to Argentina, a post he held until 1950. He subsequently served with the Israeli Embassy in Moscow from 1950 to 1953, was Ambassador to Brazil from 1956 to 1959, and Ambassador to Sweden from 1959 to 1962. He retired from the Ministry of Foreign Affairs in 1971. Aroch received the Sandberg Prize in 1968, and in 1971 was honored with the Israel Prize.

Untitled, 1969
Oil on wood
16 x 24 ⁵⁄₈ "

Acquired: 1980
Provenance: Bertha Urdang
Gallery, New York

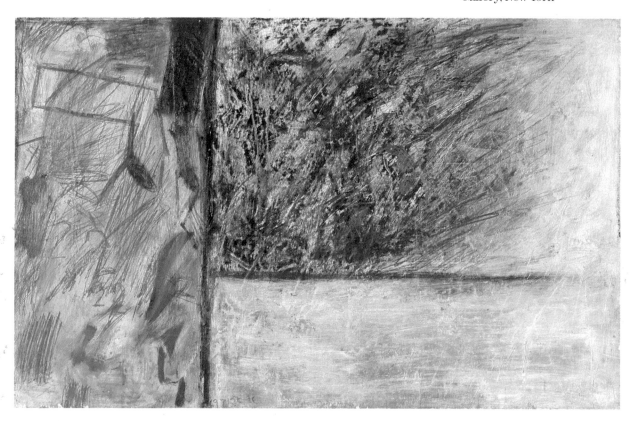

Aharon Avni

Born Yekatarinoslov, Russia, 1906
Died Tel Aviv, 1951

Aharon Avni studied at the Moscow Academy of Art from 1923 to 1925, in which year he immigrated to Palestine where he attended the Bezalel School of Arts and Crafts in Jerusalem for three years. In 1929 he began exhibiting his work with the Massad group of artists in Tel Aviv. That same year he traveled to Paris, where he continued his training for two years before returning to Jerusalem. The influence of the French Intimists is strongly reflected in his work, as evidenced by his personal, restrained, unsophisticated approach; by this means, he obtains subtle tones, soft transitions, and muted lights and shadows. In 1934 Avni had his first solo exhibition at the Bezalel Museum, and in that same year he founded the Studio for Painting and Sculpture in Tel Aviv, which he directed until his death. (It is now called the Avni Institute of Fine Arts.) Avni was awarded the Dizengoff Prize for Painting in 1937 and 1948.

Yosl Bergner

Born Vienna, 1920
Lives in Tel Aviv

Yosl Bergner's childhood was spent in Warsaw until 1937, when he immigrated to Australia. There he began his art studies, and he first exhibited with Australia's Association of Contemporary Art in the 1940s. In 1948 he left Australia and spent several years traveling and exhibiting in Paris, Montreal, and New York before finally immigrating to Israel in 1950. In the following years his paintings incorporated kitchen utensils, figures, and spaces, which he employed as symbols epitomizing the destroyed community of Eastern European Jews. Exhibitions of his work have been held at the Bezalel Museum, Jerusalem in 1955 as well as at the Haifa Museum of Modern Art in 1959 and in one-man shows at the Tel Aviv Museum in 1957, 1961, and 1975. After 1970, when he also began producing stage designs, Bergner's work took a lighter turn, and his subjects included toys, flowers, and Palestinian pioneers, rendered in an expressionist and painterly manner. He was awarded the Israel Prize in 1980.

Village Scene, 1929
Watercolor on paper
13 x 16"

Acquired: 1981
Provenance: Sam Givon, Tel Aviv

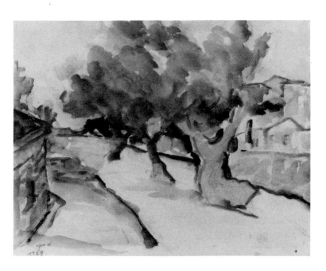

Japanese Doll, 1978
Oil on canvas
15 x 20"

Acquired: 1979
Provenance: Bineth Gallery, Tel Aviv

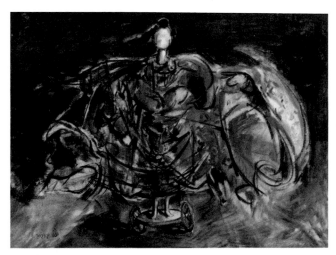

George Chemeche

Born Basra, Iraq, 1934
Lives in New York

George Chemeche immigrated to Israel in 1949,
and began his artistic training in 1956 at the Avni
Art School in Tel Aviv, where he remained for three
years. He then moved to Paris and from 1960 to 1963
studied at the Ecole des Beaux-Arts. His first one-
man show was held at the Galerie Transposition in
Paris, and it was soon followed by numerous other
solo exhibitions in Tel Aviv, Haifa, and Jerusalem.
Chemeche moved to the United States in 1972,
where he has continued to work and exhibit.

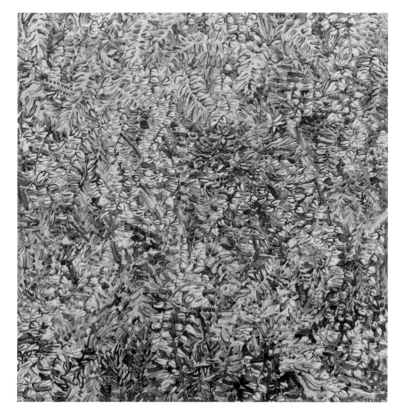

The Field, 1976
Oil on canvas
34 x 34"

Acquired: 1979
Provenance: the artist

Pinchas Cohen Gan

Born Meknes, Morocco, 1942
Lives in Jerusalem

Pinchas Cohen Gan immigrated to Israel with his family at the age of seven. He graduated from the Bezalel Academy of Arts and Design in 1970 and completed his art studies at the Central School of Art in London. In 1971 he returned to Israel and taught at the Bezalel Academy and obtained his bachelor's degree in social science and the history of art at Hebrew University. He received a masters of fine arts degree at Columbia University in New York in 1977, after which he returned to Israel.

Cohen Gan uses art to address socio-political situations, and his faceless anonymous figures depicted in a nonspecific space symbolically convey alienation. He has been accorded one-man exhibitions at The Israel Museum, Jerusalem in 1974, at the Tel Aviv Museum in 1978, the Haifa Museum of Modern Art in 1983 and at galleries in Israel and New York. In 1977 Cohen Gan represented Israel in Documenta 6 in Kassel, Germany, and was awarded the Sandberg Prize for Painting in 1979.

Color Relation of Ittan, 1978
Charcoal, oil, and gouache on paper
19½ x 25½"

Acquired: 1978
Provenance: the artist

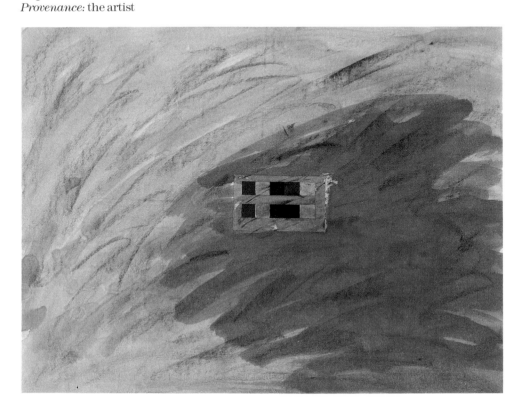

Fima

Born (Ephraim Roetenberg Fima) Harbin, China, 1916
Lives in Jerusalem and Paris

Fima retains much of the Far Eastern influence
that was ingrained in his work in the early stages
of his artistic development. He began his studies in
Harbin, where he learned painting and the art of
calligraphy, and he first utilized this knowledge in
designing stage-sets for plays, ballets, and operas.
While in China he taught art at the Shanghai Acad-
emy. His abstractions reflect the influence of Far
Eastern artistic traditions by an intermingling of
Chinese calligraphic elements with undefined fig-
urative masses. Fima immigrated to Israel in 1949,
and worked in Beersheba and Jerusalem for twelve
years. Since 1961 he has lived in Paris, although he
maintains a studio in Israel. His work has been in-
cluded in many group and solo exhibitions, which
include a one-man exhibition held at The Jewish
Museum, New York, in 1972.

Haim Glicksburg

Born Pinsk, Russia, 1904
Died Tel Aviv, 1970

Haim Glicksburg studied at the Odessa Art Acad-
emy from 1920 to 1924. Then, after a short period
in Moscow, he immigrated to Palestine in 1925. He
settled in Jerusalem and studied at the Bezalel
School of Arts and Crafts. In 1927 he exhibited his
work for the first time at the Tower of David Exhibi-
tion in that city. He directed the Studio for Paint-
ing in Tel Aviv from 1929 to 1939, during which
time his work was shown in several one-man ex-
hibitions at the Tel Aviv Museum. His work man-
ifests an affinity for Palestinian scenes, and he
employed subtle tonal variation to create an atmos-
phere of charm and intimacy in his interpreta-
tions of the views of his adopted surroundings.

The Arie Synagogue, 1965
Oil on canvas
36 x 29"

Acquired: 1980
Provenance: Sam Givon, Tel Aviv

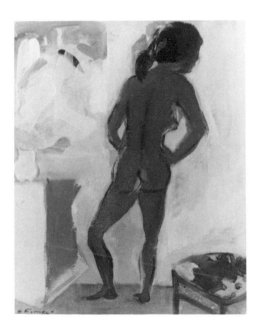

Nude, 1960
Oil on canvas
16½ x 13"

Acquired: 1979
Provenance: Bineth Gallery, Tel Aviv

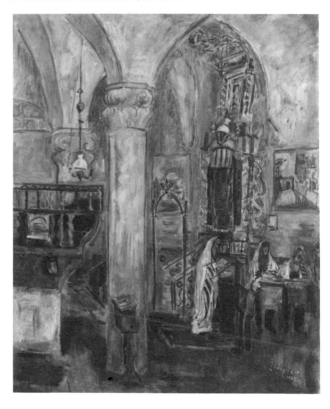

Nahum Gutman

Born Telshent, Bessarabia, 1898
Died Tel Aviv, 1980

Nahum Gutman was brought to Palestine in 1905 as a child. He was one of the first generation of painters to study at the Bezalel School of Arts and Crafts in Jerusalem. After serving in the Jewish Legion of the British Forces in Palestine during World War I, Gutman returned to the pursuit of art, and from 1920 to 1926 studied in Vienna, Paris, and Berlin. During this time, he also participated in numerous exhibitions, thus affirming his skill as both painter and illustrator. In watercolor and oil, Gutman is noted for his facile drawing and stylized colorful expression, in which landscape and the human figure are linked in an intimate, personal manner. Gutman was awarded the Dizengoff prize in 1945, and participated in the 1953 Venice Biennale and the São Paulo Bienal of 1955. His most recent one-man exhibition was held at the Tel Aviv Museum in 1984.

The Yellow Coachman, 1927
Oil on canvas
33 x 25"

Acquired: 1982
Provenance: Mrs. Nahum Gutman

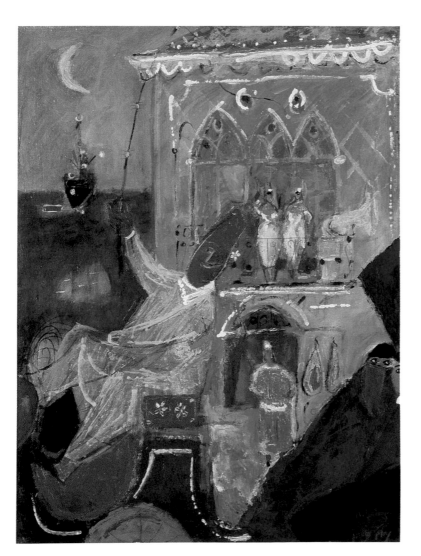

Marcel Janco

Born Bucharest, 1895
Died Tel Aviv, 1984

Marcel Janco's early studies began in 1910 in Bucharest, under the painter Iser-Josif. In 1916 Janco obtained a degree in architecture from the Polytechnique in Zurich. He was among the founders of the Dada movement in Zurich, and between 1916 and 1919 he collaborated on the four issues of the review, *Dada*. From 1921 to 1922 Janco lived in Paris, where he became involved with the then-emerging Surrealists. Taking these Dadaist and Surrealist influences with him, Janco returned to Bucharest in 1923, and pursued the double career of painter and architect. In his native city he also joined Contemporanul, a radical group of artists. In 1941 Janco immigrated to Palestine, where he became an influential teacher. From this time onward he abandoned pure abstraction in favor of a bold, angular, linear abstract mode of expression-

ism that informs his landscapes and stylized figures. Janco was among the founders of the New Horizons group in 1948, and the artists' village of Ein Hod in 1953. He was represented in the 1952 Venice Biennale and the São Paolo Bienal of 1953 and 1957; he was honored with the Dizengoff Prize for Painting in 1951, and was awarded the Israel Prize in 1967. In 1983 the Janco Museum in Ein Hod was established in his memory.

The Sheik, 1940
Oil on wood
21 x 17″

Acquired: 1977
Provenance: Engel Gallery, Jerusalem

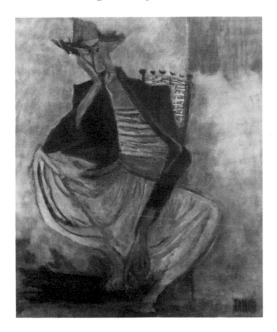

Menashe Kadishman

Born Tel Aviv, 1932
Lives in Tel Aviv

Menashe Kadishman first studied in Tel Aviv with the sculptors Rudi Lehmann and Moshe Sternschuss. This early exposure to sculpture took him to London in 1959, and there he studied at the St. Martin's School of Art and at the University of London's Slade School of Fine Arts. While in England he first began working with glass and metal, creating seemingly weightless forms that appear to defy gravity. In 1972 Kadishman returned to Israel, where he began work on outdoor installations of his massive forms. His concern with the resonance of nature in art, as well as his attachment to the land of the Bible, has led to his most recent endeavors: colorful, expressive paintings based on sheep and shepherd themes. Kadishman's paintings and large scale sculpture on the theme of the Sacrifice of Isaac, were shown at The Jewish Museum in New York in the spring of 1985. Other exhibitions were held at The Israel Museum, Jerusalem, in 1975 and 1979. In 1978 Kadishman represented Israel at the Venice Biennale, and he was awarded the Sandberg Prize that same year.

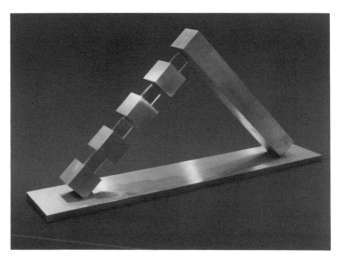

Bridges, 1977
Aluminum and Plexiglas
15½ x 31½ x 6″
Commissioned and acquired: 1977

Menashe Kadishman

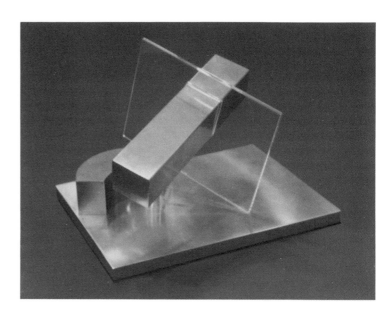

20

It Floats, 1977
Aluminum and Plexiglas
9 x 12 x 9″
Commissioned and acquired: 1977

Shadows, 1977
Aluminum and Plexiglas
(Number 3 of an edition of 7)
10 x 20 x 5″
Commissioned and acquired: 1977

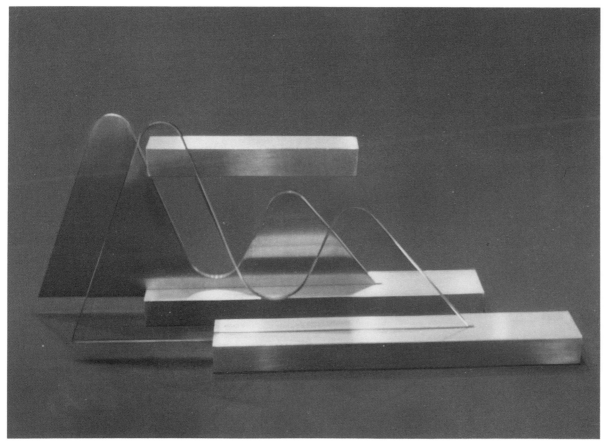

Dani Karavan

Born Tel Aviv, 1930
Lives in Tel Aviv and Paris

Dani Karavan began his training in art at the age of twelve, studying with Aharon Avni in Tel Aviv. He continued his studies of modern painting three years later with Streichman and Stematsky at their studio. After serving in the military, Karavan attended the Bezalel School of Arts and Crafts, studying under Mordecai Ardon. In 1956 Karavan studied etching and the technique of fresco at the Accademia delle Belle Arti in Florence, which was followed by a term of additional studies in Paris at the Académie de la Grande Chaumière. In addition to creating work for public buildings in Israel and abroad, Karavan has designed stage sets for ballets and plays. The forms of his major works of environmental sculpture are often determined by nature as well as by the materials used in their construction. His major achievements include a monument to the Negev Brigade (1965), Beersheba and the sculptured relief wall in the Assembly Hall of the Knesset, Jerusalem. In 1976 he was responsible for an environmental sculpture for the Israel Pavilion of the 38th Venice Biennale. Major exhibitions were held at the Musée d'Art Moderne, Paris, and the Heidelberger Kunstverein, Heidelberg in 1983 and at the DeBeyerd Museum in Breda in The Netherlands, in 1984.

Form, 1979
Aluminum and Plexiglas
9½ x 20½ x 3¼″

Acquired: 1979
Provenance: the artist

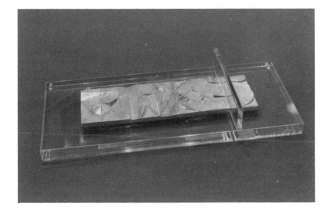

Joseph Kossonogi

Born Budapest, Hungary, 1908
Died Safed, Israel, 1981

At the age of fifteen Kossonogi was taken to Berlin, where he studied for two years at the Academy for Fine Arts. He arrived in Palestine in 1925, participated in his first group exhibition in 1928, and was accorded a one-man show in 1932. Kossonogi is essentially a watercolorist whose work embodies a discreet charm derived from nature. His intimate, lyrical watercolors employ simple, direct means to express the atmosphere of his subjects. Kossonogi combined his early method of sketching figures with a more spontaneous style of painting, which is somewhat reminiscent of Raoul Dufy. His work reflects local themes, and features soft colors to stress forms and create a delicate effect.

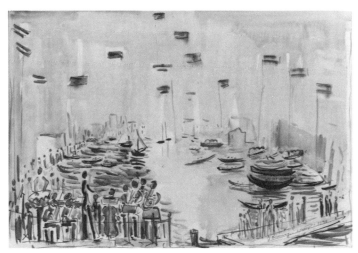

Independence Day Concert on the Yarkon, 1948
Watercolor on paper
19 x 27″

Acquired: 1983
Provenance: Sam Givon, Tel Aviv

Leopold Krakauer

Born Vienna, 1890
Died Jerusalem, 1954

Leopold Krakauer graduated from the Imperial
Academy of Fine Arts in Vienna with a degree in
engineering and architecture. He immigrated to
Palestine in 1924 and settled in Jerusalem, where
he utilized his expertise in the creation of architec-
tural plans for newly established kibbutzim. In the
1930s Krakauer began work on his black-and-white
chalk drawings, creating poetic interpretations of
the Jerusalem landscape. Krakauer also maintained
his architectural work, and continued to design
small villages for immigrants to Israel.

Zvi Mairovich

Born Krosno, Poland, 1911
Died Haifa, 1974

Zvi Mairovich began his art studies in 1929 in Berlin
with Karl Hofer at the Academy of Fine Arts. He
immigrated to Haifa in 1934, where he remained
for most of his life. For six months, in 1942, he
shared a room with the artist Arie Aroch in Zich-
ron Yaacov. Before he left for Paris—where he lived
from 1949 to 1950—Mairovich was instrumental in
establishing the New Horizons group of painters in
1948. It was during his involvement with New Hor-
izons that he came to express himself through an
abstract idiom, concentrating on landscape themes.
He later developed this style into rich and colorful
paintings, drawn with oil chalks. He represented
Israel in the Venice Biennale in 1956, 1958, and
1962, and at the São Paulo Bienal of 1953 and 1959.

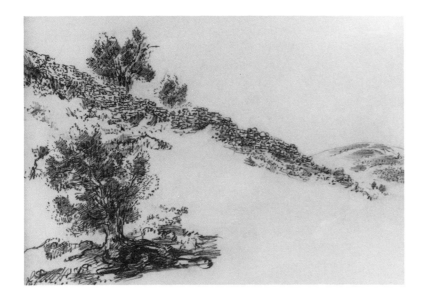

Jerusalem, 1946
Charcoal on paper
22 x 30"

Acquired: 1983
Provenance: the artist's daughter, Trude Dothan

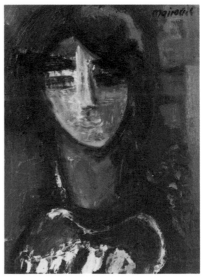

Portrait, 1951
Oil on canvas
13¼ x 10"

Acquired: 1979
Provenance: Hillel Gallery, Jerusalem

Abel Pann

Born (Pfeffermann) Kraslava, Lithuania, 1883
Died Jerusalem, 1963

Abel Pann studied under Bouguereau in Paris. He became a successful painter and cartoonist, and his drawings depicting the Czarist pogroms in Lithuania caused a sensation at the time. He visited Palestine in 1913, settling there in 1920. Pann had a great interest in illustrating the Bible in the historicist terms of its original setting, and he used local "oriental" types as models to depict biblical characters. As one of the first teachers at the Bezalel School of Arts and Crafts, Pann's romantic-idealistic perception of the biblical era influenced many young Israeli artists. In 1922 his work was exhibited at the Tower of David in Jerusalem, and subsequent showings of his work followed in Palestine and in the West.

Mother and Child, 1912
Tempera and crayon on wood
16 x 10½"

Acquired: 1977
Provenance: Engel Gallery, Jerusalem

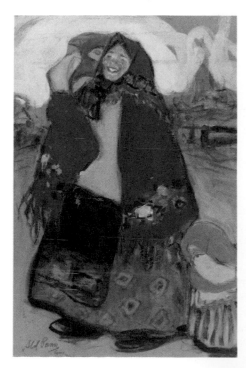

Joshua Neustein

Born Danzig, Poland, 1940
Lives in New York and Jerusalem

Joshua Neustein spent the years of World War II as a refugee from Nazi terrorism. After the war he left Europe and moved to New York where he studied at the Yeshiva Rabbi Jacob Joseph from 1951 to 1956. His interest in art led him to the Art Students League in 1959, and, eventually, to Pratt Institute in 1960. He received a Bachelor's Degree from the College of the City of New York in 1961. In 1964 Neustein settled in Israel, and studied with Zvi Mairovich and Arie Aroch in Jerusalem. In 1974 he began teaching at the Bezalel Academy of Arts and Design, and in 1975 became the editor of the periodical *Art en Garde.* Neustein's uniquely personal art often imposes various methods in which the surface or material is torn, folded, creased, or marked, thus creating three dimensional, textured "objects" that fold out from the wall. In 1983 one-man exhibitions of Neustein's work were held at the Herbert F. Johnson Museum of Art, Cornell University, Ithaca, New York, and at The Israel Museum, Jerusalem. Neustein was honored with the Jerusalem Prize in 1971 and with the Sandberg Prize in 1973.

Blue Pillar, 1980
Oil and acrylic on paper
26 x 37½"

Acquired: 1982
Provenance: the artist

Elias Newman

Born Staslow, Poland, 1903
Lives in New York

Brought to New York at an early age, Elias Newman studied at the National Academy of Design and painted at the Educational Alliance. In 1925 he immigrated to Israel, where he stayed for the next ten years. He became actively involved with the burgeoning Palestinian art community, and in 1927 exhibited his work together with that of Reuven Rubin at the Menorah Club in Tel Aviv. Newman's art reveals an emotional restraint, and it captures the Near Eastern atmosphere with which he was familiar, conveying it in rich, sombre tones. Since 1935 Newman has made his home in New York, while spending long periods in Israel.

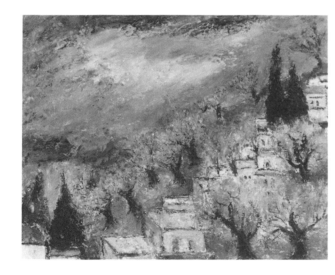

Safed in Galilee, 1972–73
Encaustic on canvas
20 x 24"

Acquired: 1982
Provenance: the artist

Lea Nikel

Born Zhitomir, Ukraine, 1918
Lives in Jaffa

Lea Nikel immigrated to Palestine with her family as an infant. She began her studies in the 1940s in Tel Aviv with Haim Glicksburg, Avigdor Stematsky, and Yeheskel Streichman. Nikel remained in Israel until 1950, when she moved to Paris. It was there that she developed a bold, abstract style, dominated by rich, vibrant colors. She remained in Paris until 1961, when she returned to Israel to work in Safed, Ashdod, and Tel Aviv. She lived in Rome from 1968 to 1970, and in New York from 1963–64 and 1975–78. In 1964 Nikel represented Israel in the Venice Biennale, and in 1972 she was honored with the Sandberg Prize, and a retrospective of her work was held at The Israel Museum, Jerusalem, that same year and again in 1984.

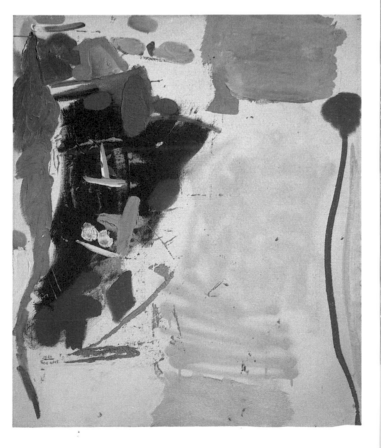

Painting in Red, 1966
Oil on canvas
29 x 24"

Acquired: 1979
Provenance: the artist

Israel Paldi

Born (Feldman) Berdyansk, Ukraine, 1893
Died Tel Aviv, 1979

Israel Paldi lived in Switzerland as a child, and immigrated to Palestine at the age of seventeen. He began his artistic training at the Bezalel School of Arts and Crafts in Jerusalem. After two years he moved to Munich, where he studied at the Staatliche Kunstakademie. Upon finishing his studies there, Paldi lived in Constaninople for six years, and in 1920 returned to Palestine to teach and paint. His early work reveals a powerful and vital painterly style and seems to have its roots in the land. In the 1920s he participated in the Jerusalem Tower of David Exhibitions. He also resided in Paris in 1929, 1931, and from 1958 to 1960. Throughout his career his work underwent considerable change, ranging from an early modernist style to a subsequent focus on "oriental" genre scenes, and finally to abstract reliefs and assemblages. He has twice been awarded the Dizengoff Prize for Painting, first in 1953 and again in 1959.

Impressions of Safed, 1927
Oil on canvas
15 x 22"

Acquired: 1979
Provenance: the artist

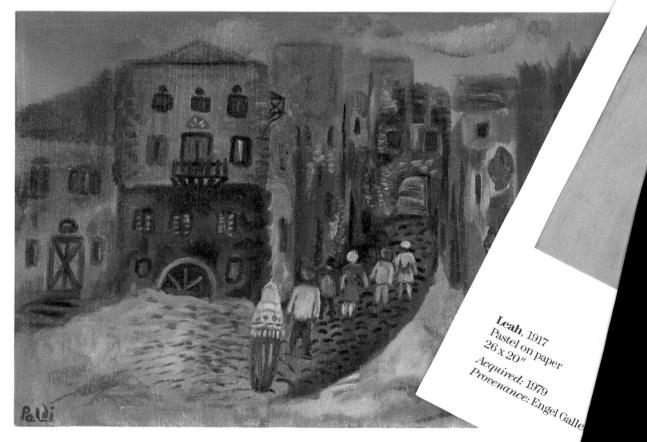

Leah, 1917
Pastel on paper
26 x 20"
Acquired: 1979
Provenance: Engel Galle

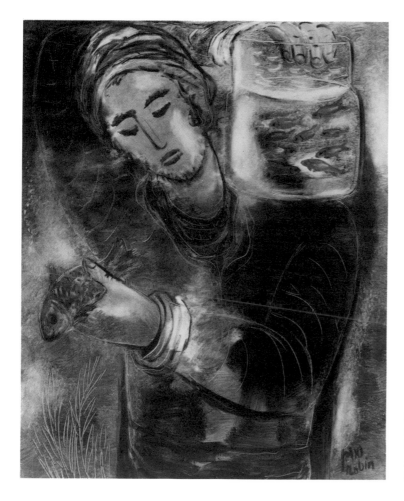

Goldfish Vendor, 1972
Oil on canvas
36 x 29"

Acquired: 1983
Provenance: Mrs. Reuven Rubin

Reuven Rubin

Born Galatz, Rumania, 1893
Died Caesarea, 1974

In 1912 Reuven Rubin first visited Jerusalem, where he attended the Bezalel School of Arts and Crafts. The following year he went to Paris and studied at the Ecole des Beaux-Arts and the Académie Colarossi. He returned to Rumania in 1916 and taught in Czernowitz. In 1920 Rubin came to New York—the first of many such visits—where he was given a one-man exhibition. In 1922 he returned to Palestine and established a studio in Tel Aviv. Two years later he became the chairman of the Association of Painters and Sculptors, and in 1932 a one-man exhibition of his work inaugurated the Tel Aviv Museum. He continued to make frequent visits to New York, and in 1940 settled there for five years. The remainder of his life was spent primarily in Israel, with a brief interval in Rumania as the Israeli Minister. In the 1960s Rubin traveled extensively, exhibiting his work in the United States and Europe. His direct and representational paintings convey a deep affection for Israel and its people, and his poetic and romantic interpretation of his chosen subject matter have made him an influential force in Israeli art. In 1970 Rubin was honored with the Israel Prize.

Ivan Schwebel

Born Morgantown, West Virginia, 1932
Lives in Ein Karem, Israel

Ivan Schwebel was raised in New York. He served in the United States Army from 1953 to 1955, and in 1956 began his study of art history at the Institute of Fine Arts of New York University. In 1960 he completed his studies and spent the following year traveling through Europe. In 1963 he moved to Ein Karem, a small village near Jerusalem. Schwebel is a self-taught painter, but whether his subject is a landscape or a still-life, his work reveals a vital and expressive deployment of line and color that communicates directly to the viewer. His work has been exhibited since 1965 in The Israel Museum, Jerusalem and in several galleries in Tel Aviv and abroad.

28

Samuel 6:14, 1980
Oil on canvas
40 x 35″

Commissioned: 1979
Acquired: 1980

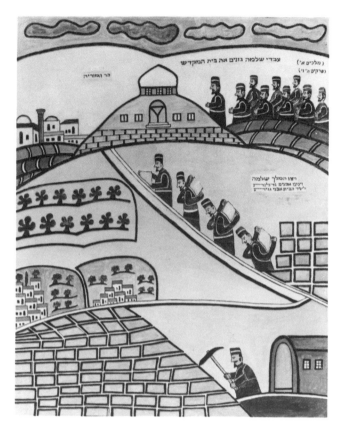

עבדי שלמה בונים את בית המקדש

(מלכים א')

(דה"ב ג' ו')

הר המוריה

ויצו המלך שלמה

דיסעו אבנים גדולות

לייסד הבית אבני גזית

Shlomo Hamelekh, 1964
Oil on canvas
19½ x 15½"

Acquired: 1979
Provenance: Engel Gallery, Jerusalem

Shalom of Safed

Born (Shalom Moscovitz) Safed, Palestine, 1890
Died Safed, 1980

For over seventy years before his artistic talents
were discovered Shalom of Safed lived in the town
from which he took his name. At the encourage-
ment of the painter Yosl Bergner, Shalom began to
paint in the late 1950s. His naive style was born of
an innocence and ignorance of artistic tradition;
nevertheless his work reflects a thorough knowl-
edge and recognition of the biblical history and
Hassidic heritage that he portrays. His work first
attained recognition in 1967, when a one-man ex-
hibition was held at The Israel Museum in Jerusalem.

Zvi Shor

Born Satonof, Ukraine, 1898
Died Tel Aviv, 1980

Zvi Shor immigrated to Palestine in 1921. Although he had no formal art training—he began to draw while still a student in yeshiva—his painting was encouraged by Hermann Struck. In 1931 his first one-man exhibition opened in Tel Aviv. A visit to Paris in 1936 provided Shor the opportunity to become acquainted with the Jewish artists of that city and greatly influenced his stylistic attitude; in fact his work recalls that of many of the Jewish artists of the School of Paris. Objects and figures are usually defined by means of rich color and applied with delicacy and discretion. His interpretations of Tel Aviv in its early days are personal and poetic, manifesting a controlled and moderate type of Expressionism. Shor returned to Palestine in 1938, where he joined Kibbutz Giv'at HaShelosha. From there, he organized exhibitions of kibbutz artists and taught art. Years later he directed an art studio in Petah Tikva.

Jakob Steinhardt

Born Zerkow, Poland, 1887
Died Naharyia, Israel, 1968

Jakob Steinhardt studied with many eminent masters: etching under Lovis Corinth and Hermann Struck in 1906 in Berlin; and in Paris in 1909, under Henri Laurens, Théophile Steinlen, and Henri Matisse. After a brief visit to Italy he returned to Berlin in 1912 and cofounded an Expressionist group of artists known as the Pathetiker. It was here that he began exhibiting his work. During World War I he accompanied the German army as a war artist. While stationed in Lithuania, Steinhardt was exposed to the *shtetl* communities and their traditional Jews, which left a lasting impression on the artist. He made a short visit to Palestine in 1925, immigrated there in 1933, settling in Jerusalem. He continued to work in a stark German Expressionist tradition, creating black-and-white woodcuts reflecting social and biblical themes. In 1949 Steinhardt became chairman of the graphics

Tel Aviv, 1929
Oil on canvas
9½ x 11½"

Acquired: 1983
Provenance: Givon Gallery, Tel Aviv

The Kotel, 1944
Oil on canvas
22 x 28"

Acquired: 1980
Provenance: Engel Galleries, Jerusalem

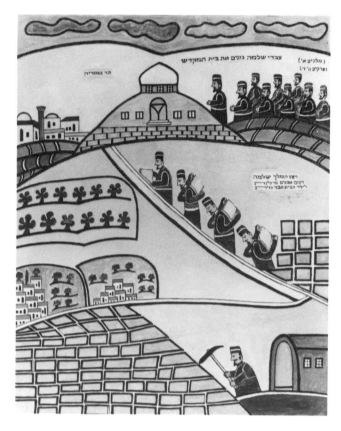

עבדי שלמה בונים את בית המקדש (מלכים א')
(פרקים ה' ו')

הר המוריה

ויצו המלך שלמה
ויסיעו אבנים גדילות
ליסד הבית אבני גזית

Shlomo Hamelekh, 1964
Oil on canvas
19½ x 15½″

Acquired: 1979
Provenance: Engel Gallery, Jerusalem

Shalom of Safed

Born (Shalom Moscovitz) Safed, Palestine, 1890
Died Safed, 1980

For over seventy years before his artistic talents
were discovered Shalom of Safed lived in the town
from which he took his name. At the encourage-
ment of the painter Yosl Bergner, Shalom began to
paint in the late 1950s. His naive style was born of
an innocence and ignorance of artistic tradition;
nevertheless his work reflects a thorough knowl-
edge and recognition of the biblical history and
Hassidic heritage that he portrays. His work first
attained recognition in 1967, when a one-man ex-
hibition was held at The Israel Museum in Jerusalem.

Zvi Shor

Born Satonof, Ukraine, 1898
Died Tel Aviv, 1980

Zvi Shor immigrated to Palestine in 1921. Although he had no formal art training—he began to draw while still a student in yeshiva—his painting was encouraged by Hermann Struck. In 1931 his first one-man exhibition opened in Tel Aviv. A visit to Paris in 1936 provided Shor the opportunity to become acquainted with the Jewish artists of that city and greatly influenced his stylistic attitude; in fact his work recalls that of many of the Jewish artists of the School of Paris. Objects and figures are usually defined by means of rich color and applied with delicacy and discretion. His interpretations of Tel Aviv in its early days are personal and poetic, manifesting a controlled and moderate type of Expressionism. Shor returned to Palestine in 1938, where he joined Kibbutz Giv'at HaShelosha. From there, he organized exhibitions of kibbutz artists and taught art. Years later he directed an art studio in Petah Tikva.

Jakob Steinhardt

Born Zerkow, Poland, 1887
Died Naharyia, Israel, 1968

Jakob Steinhardt studied with many eminent masters: etching under Lovis Corinth and Hermann Struck in 1906 in Berlin; and in Paris in 1909, under Henri Laurens, Théophile Steinlen, and Henri Matisse. After a brief visit to Italy he returned to Berlin in 1912 and cofounded an Expressionist group of artists known as the Pathetiker. It was here that he began exhibiting his work. During World War I he accompanied the German army as a war artist. While stationed in Lithuania, Steinhardt was exposed to the *shtetl* communities and their traditional Jews, which left a lasting impression on the artist. He made a short visit to Palestine in 1925, immigrated there in 1933, settling in Jerusalem. He continued to work in a stark German Expressionist tradition, creating black-and-white woodcuts reflecting social and biblical themes. In 1949 Steinhardt became chairman of the graphics

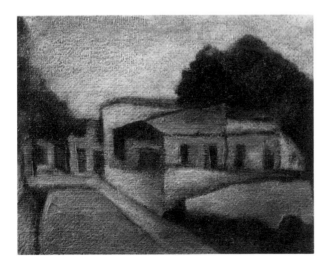

Tel Aviv, 1929
Oil on canvas
9½ x 11½"

Acquired: 1983
Provenance: Givon Gallery, Tel Aviv

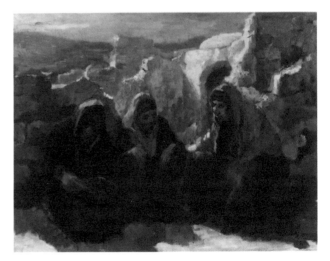

The Kotel, 1944
Oil on canvas
22 x 28"

Acquired: 1980
Provenance: Engel Galleries, Jerusalem

Joshua Neustein

Born Danzig, Poland, 1940
Lives in New York and Jerusalem

Joshua Neustein spent the years of World War II as a refugee from Nazi terrorism. After the war he left Europe and moved to New York where he studied at the Yeshiva Rabbi Jacob Joseph from 1951 to 1956. His interest in art led him to the Art Students League in 1959, and, eventually, to Pratt Institute in 1960. He received a Bachelor's Degree from the College of the City of New York in 1961. In 1964 Neustein settled in Israel, and studied with Zvi Mairovich and Arie Aroch in Jerusalem. In 1974 he began teaching at the Bezalel Academy of Arts and Design, and in 1975 became the editor of the periodical *Art en Garde*. Neustein's uniquely personal art often imposes various methods in which the surface or material is torn, folded, creased, or marked, thus creating three dimensional, textured "objects" that fold out from the wall. In 1983 one-man exhibitions of Neustein's work were held at the Herbert F. Johnson Museum of Art, Cornell University, Ithaca, New York, and at The Israel Museum, Jerusalem. Neustein was honored with the Jerusalem Prize in 1971 and with the Sandberg Prize in 1973.

Blue Pillar, 1980
Oil and acrylic on paper
26 x 37½"

Acquired: 1982
Provenance: the artist

Elias Newman

Born Staslow, Poland, 1903
Lives in New York

Brought to New York at an early age, Elias Newman studied at the National Academy of Design and painted at the Educational Alliance. In 1925 he immigrated to Israel, where he stayed for the next ten years. He became actively involved with the burgeoning Palestinian art community, and in 1927 exhibited his work together with that of Reuven Rubin at the Menorah Club in Tel Aviv. Newman's art reveals an emotional restraint, and it captures the Near Eastern atmosphere with which he was familiar, conveying it in rich, sombre tones. Since 1935 Newman has made his home in New York, while spending long periods in Israel.

Lea Nikel

Born Zhitomir, Ukraine, 1918
Lives in Jaffa

Lea Nikel immigrated to Palestine with her family as an infant. She began her studies in the 1940s in Tel Aviv with Haim Glicksburg, Avigdor Stematsky, and Yeheskel Streichman. Nikel remained in Israel until 1950, when she moved to Paris. It was there that she developed a bold, abstract style, dominated by rich, vibrant colors. She remained in Paris until 1961, when she returned to Israel to work in Safed, Ashdod, and Tel Aviv. She lived in Rome from 1968 to 1970, and in New York from 1963–64 and 1975–78. In 1964 Nikel represented Israel in the Venice Biennale, and in 1972 she was honored with the Sandberg Prize, and a retrospective of her work was held at The Israel Museum, Jerusalem, that same year and again in 1984.

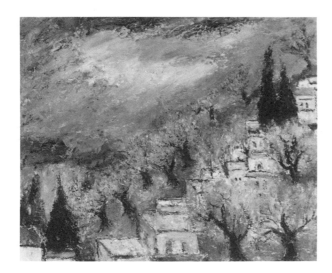

Safed in Galilee, 1972–73
Encaustic on canvas
20 x 24″

Acquired: 1982
Provenance: the artist

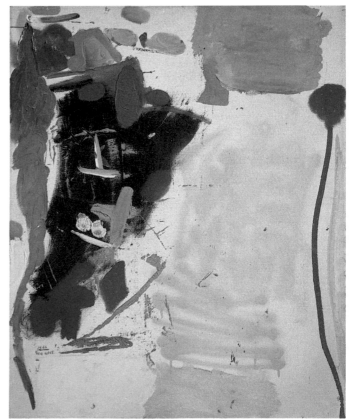

Painting in Red, 1966
Oil on canvas
29 x 24″

Acquired: 1979
Provenance: the artist

Israel Paldi

Born (Feldman) Berdyansk, Ukraine, 1893
Died Tel Aviv, 1979

Israel Paldi lived in Switzerland as a child, and immigrated to Palestine at the age of seventeen. He began his artistic training at the Bezalel School of Arts and Crafts in Jerusalem. After two years he moved to Munich, where he studied at the Staatliche Kunstakademie. Upon finishing his studies there, Paldi lived in Constaninople for six years, and in 1920 returned to Palestine to teach and paint. His early work reveals a powerful and vital painterly style and seems to have its roots in the land. In the 1920s he participated in the Jerusalem Tower of David Exhibitions. He also resided in Paris in 1929, 1931, and from 1958 to 1960. Throughout his career his work underwent considerable change, ranging from an early modernist style to a subsequent focus on "oriental" genre scenes, and finally to abstract reliefs and assemblages. He has twice been awarded the Dizengoff Prize for Painting, first in 1953 and again in 1959.

Impressions of Safed, 1927
Oil on canvas
15 x 22"

Acquired: 1979
Provenance: the artist

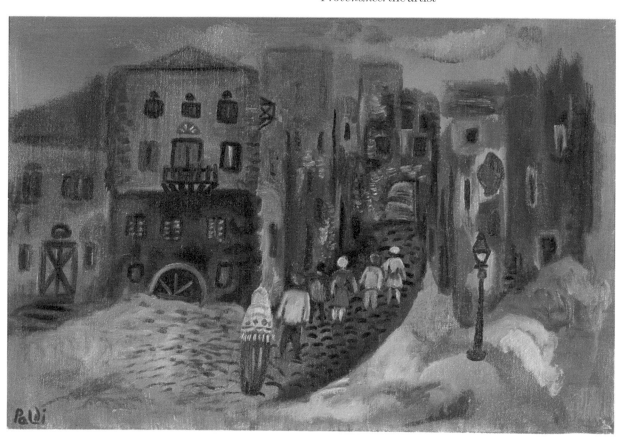

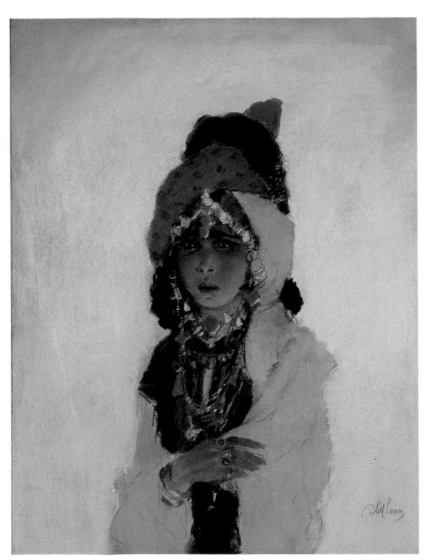

Abel Pann

Born (Pfeffermann) Kraslava, Lithuania, 1883
Died Jerusalem, 1963

Abel Pann studied under Bouguereau in Paris. He became a successful painter and cartoonist, and his drawings depicting the Czarist pogroms in Lithuania caused a sensation at the time. He visited Palestine in 1913, settling there in 1920. Pann had a great interest in illustrating the Bible in the historicist terms of its original setting, and he used local "oriental" types as models to depict biblical characters. As one of the first teachers at the Bezalel School of Arts and Crafts, Pann's romantic-idealistic perception of the biblical era influenced many young Israeli artists. In 1922 his work was exhibited at the Tower of David in Jerusalem, and subsequent showings of his work followed in Palestine and in the West.

Mother and Child, 1912
Tempera and crayon on wood
16 x 10½"

Acquired: 1977
Provenance: Engel Gallery, Jerusalem

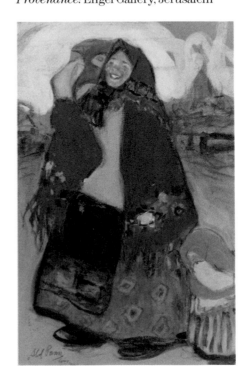

Leah, 1917
Pastel on paper
26 x 20"

Acquired: 1979
Provenance: Engel Gallery, Jerusalem

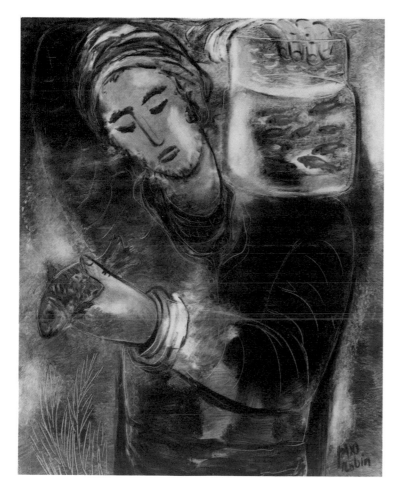

Goldfish Vendor, 1972
Oil on canvas
36 x 29″

Acquired: 1983
Provenance: Mrs. Reuven Rubin

Reuven Rubin

Born Galatz, Rumania, 1893
Died Caesarea, 1974

In 1912 Reuven Rubin first visited Jerusalem, where he attended the Bezalel School of Arts and Crafts. The following year he went to Paris and studied at the Ecole des Beaux-Arts and the Académie Colarossi. He returned to Rumania in 1916 and taught in Czernowitz. In 1920 Rubin came to New York—the first of many such visits—where he was given a one-man exhibition. In 1922 he returned to Palestine and established a studio in Tel Aviv. Two years later he became the chairman of the Association of Painters and Sculptors, and in 1932 a one-man exhibition of his work inaugurated the Tel Aviv Museum. He continued to make frequent visits to New York, and in 1940 settled there for five years. The remainder of his life was spent primarily in Israel, with a brief interval in Rumania as the Israeli Minister. In the 1960s Rubin traveled extensively, exhibiting his work in the United States and Europe. His direct and representational paintings convey a deep affection for Israel and its people, and his poetic and romantic interpretation of his chosen subject matter have made him an influential force in Israeli art. In 1970 Rubin was honored with the Israel Prize.

Ivan Schwebel

Born Morgantown, West Virginia, 1932
Lives in Ein Karem, Israel

Ivan Schwebel was raised in New York. He served in the United States Army from 1953 to 1955, and in 1956 began his study of art history at the Institute of Fine Arts of New York University. In 1960 he completed his studies and spent the following year traveling through Europe. In 1963 he moved to Ein Karem, a small village near Jerusalem. Schwebel is a self-taught painter, but whether his subject is a landscape or a still-life, his work reveals a vital and expressive deployment of line and color that communicates directly to the viewer. His work has been exhibited since 1965 in The Israel Museum, Jerusalem and in several galleries in Tel Aviv and abroad.

28

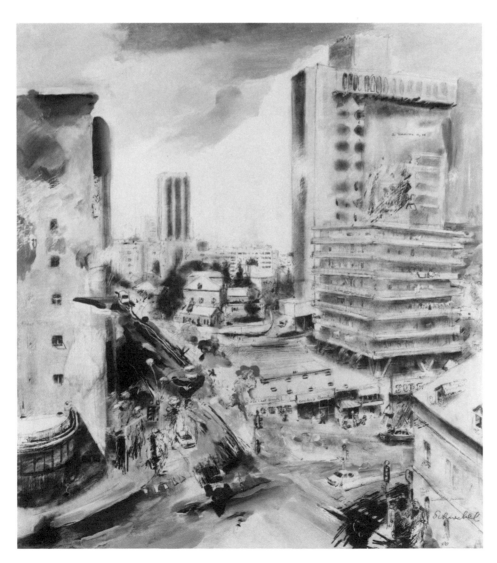

Samuel 6:14, 1980
Oil on canvas
40 x 35"

Commissioned: 1979
Acquired: 1980

department at the Bezalel School of Arts and Crafts; and served as Director of the school from 1953 to 1957. He was honored with an international prize in graphic art at the 1955 São Paulo Bienal and was awarded a liturgical award for woodcuts at the 1960 Venice Biennale.

Avigdor Stematsky

Born Odessa, Russia, 1908
Lives in Tel Aviv

Avigdor Stematsky immigrated to Palestine in 1920 and studied at the Haifa Technion and then at the Bezalel School of Arts and Crafts. In 1930 he spent a year in Paris, studying at the Académie de la Grande Chaumière and at the Académie Colarossi. Between 1944 and 1948 he taught at a studio in Tel Aviv with Streichman and Janco. Stematsky was among the founders of the New Horizons group of abstract artists, adopting the style known as Lyrical Abstraction to create vibrant compositions with splashes of rich color. Although he has periodically worked in Paris and Jerusalem, he resides in Tel Aviv. From 1950 to 1960 Stematsky taught at the Avni Art Institute. He was honored with the Dizengoff Prize for Painting in 1941 and in 1956; the Ramat Gan Prize in 1958; The Israel Museum Sherman Prize in 1972; and the Sandberg Prize in 1976. He participated in the 1948 and 1956 Venice Biennale, and the São Paulo Bienal of 1955.

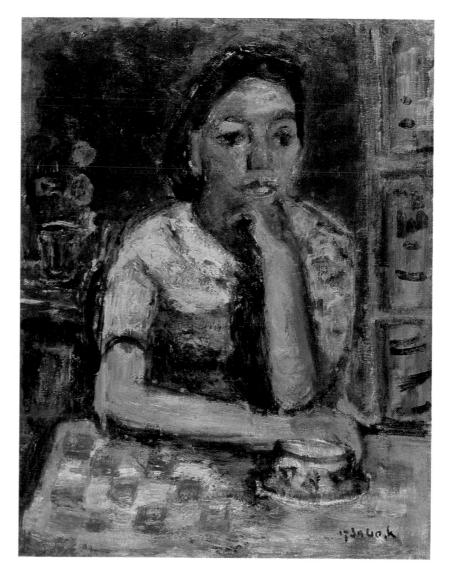

Woman and Cup of Tea, 1950
Oil on canvas
24 x 18″

Acquired: 1981
Provenance: the artist

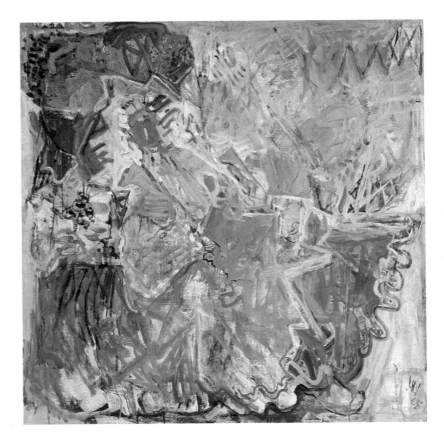

Zila, 1965
Oil on canvas
40 x 40"

Acquired: 1979
Provenance: Hillel Gallery, Jerusalem

Yeheskel Streichman

Born Kovno, Lithuania, 1906
Lives in Tel Aviv

Yeheskel Streichman immigrated to Palestine at the age of eighteen and began his studies at the Bezalel School of Arts and Crafts. He subsequently underwent concentrated training in both art and architecture in Paris and in Florence. Streichman made a short sojourn to his birthplace in 1931, and then returned to Palestine, where he joined Kibbutz Ashdot Yaakov in 1936. He eventually settled in Tel Aviv, and in 1948 helped establish the New Horizons group. He was influential in developing Lyrical Abstraction as a dominant local style, using splashes of rich, vibrant color in carefully balanced compositions. Streichman—who taught at the Avni Art Institute during the 1950s—has been the recipient of numerous awards, including the Dizengoff Prize for Painting in 1941, 1944, 1954, and 1969, the Ramat Gan Municipality Prize in 1956, the Milo Prize in 1968, the Sandberg Prize in 1974, and the Citizen of Tel Aviv Award in 1981.

Hermann Struck

Born Berlin, 1876
Died Haifa, 1944

Hermann Struck studied painting at the Berlin Academy of Fine Arts under the famous portraitist Max Kaner, and was introduced to the art of etching by Hans Meyer. After making several study trips throughout Europe, Struck visited Palestine in 1903. During World War I Struck served with the German army in Lithuania. There he came in contact with East European Jewry, an encounter that was to have a great influence on his work. Though he has painted in oil and watercolor, it was his etchings of religious Jews and scenes from Jewish life that established Struck's international reputation, and he was a leading figure in various group exhibitions throughout Germany. A master of his craft, and an excellent teacher, Struck taught graphic techniques to Chagall, Liebermann, Israels, and Corinth. His book *The Art of Etching* (1923) is considered a basic work on the subject. Struck revisited Palestine in 1921, and a year later built his home in Haifa.

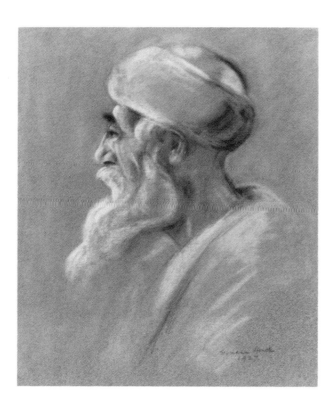

Sephardic Elder, 1927
Pastel on paper
12 x 10″

Acquired: 1981
Provenance: Mrs. Hermann Struck

Tziona Tagger

Born Jaffa, Palestine, 1900
Lives in Tel Aviv

Tziona Tagger, modern Israel's first native-born
painter, studied at the Bezalel School of Arts and
Crafts in Jerusalem, and in Paris with André Lhote
in 1924. In the early 1920s Tagger was instrumen-
tal in establishing the Hebrew Artists' Association.
A return visit to Paris in 1930 enabled her to study
at the Académie de la Grand Chaumière and the
Académie Colarossi. Her first works were portraits
that were faithful in their rendering of character as
well as likeness; she then turned to landscapes,
which reveal the influence of her early Palestinian
colleagues, Rubin and Paldi, as well as the School of
Paris painters Derain and Vlaminck. In 1950 she
returned once more to Paris, and in both portrait
and landscape painting there is an emphasis on
expressive effects. Tagger was honored with the
Dizengoff Prize for Painting in 1937.

Old City, Jerusalem, 1936
Oil on canvas
20 x 28″

Acquired: 1981
Provenance: the artist

The Clown, 1925
Oil on canvas
36 x 24″

Acquired: 1983
Provenance: the artist

34

Moshe Tamir

Born (Tulchinsky) Tigina, Russia, 1924
Lives in Jerusalem

With his parents, Moshe Tamir immigrated to Palestine in 1932, when he was eight. He began his art studies at the Bezalel School of Arts and Crafts in Jerusalem, graduating in 1947. After sustaining serious wounds in the War of Independence, he went to Rome and continued his studies from 1950 to 1952. Shortly thereafter he moved to Paris, where he worked for seven years until 1961, when he returned to Israel and served for one year as associate director of the Bezalel School of Arts and Crafts. The following year he was appointed artistic advisor to the Ministry of Education and Culture, a position he still holds. Tamir's early work embodies a stylized, realistic idiom, but in recent years he has concentrated on painting forceful works that incorporate bold gestures and rich textures in an abstract style. Tamir's work was shown at the 1954 Venice Biennale and the São Paulo Bienal of 1961.

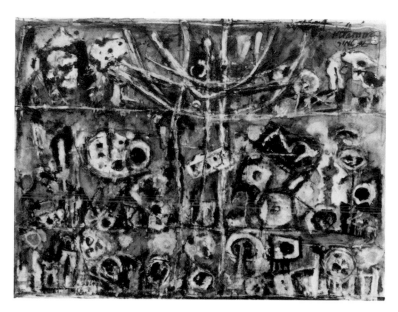

Menorah, 1953
Watercolor and crayon on paper
19½ x 25″

Acquired: 1979
Provenance: the artist

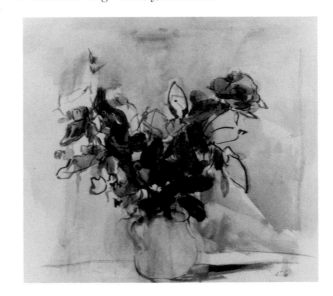

36

Anna Ticho

Born Brünn, Austria, 1894
Died Jerusalem, 1980

Anna Ticho first studied art in Vienna in 1909. She settled in Jerusalem in 1912, but left for Damascus with her husband five years later. In 1919 she returned to Jerusalem, where she pursued her own work while assisting her husband in his renowned eye-surgery clinic. A visit to Paris in 1930 influenced her art, and she began working on black-and-white drawings rendered from nature. From the 1960s until her death, she concentrated on imaginary scenes incorporating the hills, rocks and olive trees of the Jerusalem landscape, employing pastel tonalities to attain expressive effect. A one-woman exhibition of Ticho's drawings was shown at The Jewish Museum, New York in 1970 and again in 1983; and one-woman shows were held at The Israel Museum, Jerusalem, and the Tel Aviv Museum in 1973–74, and again in 1978. Ticho's honors include: the City of Jerusalem art prize of 1965, the 1975 Sandberg Prize, and the 1980 Israel Prize.

Givat Ram, 1940
Watercolor and ink on paper
18½ x 27″

Acquired: 1977
Provenance: Engel Gallery, Jerusalem

Flowers, 1950
Watercolor on paper
18½ x 20½″

Acquired: 1979
Provenance: Engel Gallery, Jerusalem

Aviva Uri

Born Safed, Palestine, 1927
Lives in Tel Aviv

Aviva Uri studied drawing in Tel Aviv with David Hendler, whom she later married. Her bold and expressive abstract drawings are developed through spontaneous, rhythmic hand gestures. Individual exhibitions of Aviva Uri's work were held at The Israel Museum, Jerusalem, in 1971 and at the Tel Aviv Museum in 1977. She represented Israel at the São Paolo Bienal in 1983. The following year saw a retrospective exhibition of her drawings at the Stedelijk Museum in Amsterdam.

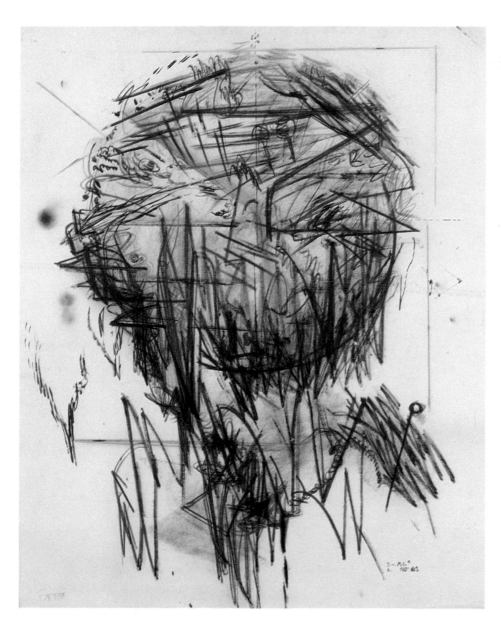

Formula, 1961
Drawing on paper
23½ x 19″

Acquired: 1981
Provenance: Givon Gallery, Tel Aviv

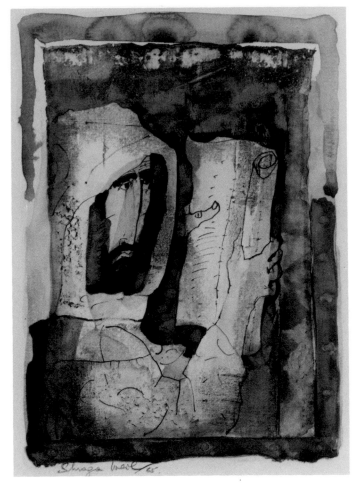

The Reader, 1965
Watercolor on paper
16 x 12"

Acquired: 1965
Provenance: the artist

Shraga Weil

Born Nitra, Czechoslovakia, 1918
Lives on Kibbutz Haogen, Israel

Shraga Weil, who studied at the Prague School of Art, produced his first graphic works during World War II. In 1947 he immigrated to Israel, where he joined Kibbutz Haogen. In 1954 he spent some time in Paris, where he studied at the Académie des Beaux-Arts, and shortly thereafter he began exhibiting his work. His first one-man show at the Tel Aviv Museum in 1960 was followed by other solo exhibitions both in Israel and the United States. Weil's art fuses passages from the Bible and the Jewish past and he employs vivid colors, textures, and drawing to create a unique world. Weil has received commissions for murals and decorative work for several public buildings, most notably the Knesset in Jerusalem, the doors of the President's House in Jerusalem, and the ceiling of the President's Reception Hall at the Kennedy Center in Washington, D.C. Weil was awarded the Dizengoff Prize in 1959.

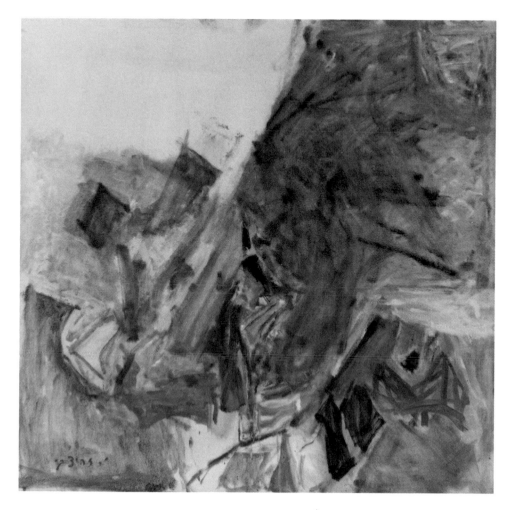

Tsova, 1970
Oil on canvas
39½ x 39″

Acquired: 1980
Provenance: the artist

Yosef Zaritsky

Born Borispol, Ukraine, 1891
Lives in Tel Aviv and on Kibbutz Tsova

Yosef Zaritsky graduated from the Kiev Academy of Arts in 1914; nine years later he immigrated to Palestine and began to produce watercolor landscapes and still-lifes. In 1925 Zaritsky organized the country's first general exhibition of art in the Tower of David, Jerusalem. He served as chairman of the Association of Painters and Sculptors of Palestine until 1948, when he left to take an active role in the formation and leadership of the New Horizons group of abstract artists. In the 1950s he abandoned representational art in favor of Lyrical Abstraction, us-

ing thick splashes of color in large, balanced compositions. He lived and worked in Paris and Amsterdam from 1954 to 1956; and though brief, this period saw the creation of an important body of work. Zaritsky was awarded the Israel Prize in 1959, and the Sandberg Prize in 1967. Although he had been accorded small one-man shows at the Bezalel Museum, The Israel Museum, Jerusalem, and the Tel Aviv Museum, Zaritsky's first major retrospective exhibition was held at the Tel Aviv Museum in 1984.